Dali's Mustache

A
Photographic
Interview

by

SALVADOR DALI

and

PHILIPPE HALSMAN

Flammarion

TO GALA

Who is the guardian angel of my mustache also.

—Dali

TO YVONNE

For whom I shave daily.

—Philippe Halsman

Typesetting by P.F.C., Dole

26, rue Racine
75006 Paris

www.editions.flammarion.com

04 05 06 11 10 9 8

FC0466-04-V
ISBN: 2-0803-0466-6
Dépôt légal: 05/2004

Printed in Spain

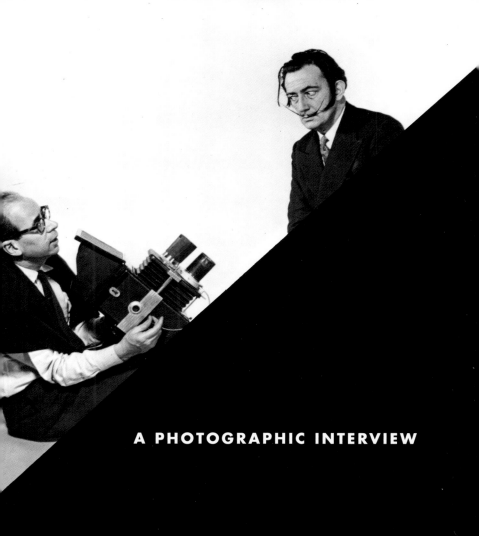

A PHOTOGRAPHIC INTERVIEW

TABLE OF CONTENTS

FOREWORD
to the Second Edition

LONG before photography became popularly recognized as an art form, a handful of individualistic photographers were dedicating themselves to raising the level of the medium. In many cases, they did so by generating *ideas* to be recorded on film. Such names include, among others, Man Ray, Brassaï, Ansel Adams, Edward Steichen, Cecil Beaton, and Philippe Halsman.

In grappling with Dali, Philippe Halsman went far beyond the usual. The camera has only one eye, and Halsman was among the first of these lensmen to modify the film itself. He also added a new dimension of wit and humor. In cooperation with the world-famous and awesome Dali, Halsman veered near surrealism and seized the opportunity to include Dali's comical imagination in what was put before the camera. In some instances, Halsman then reworked the silver images, creating a finished work that no mechanical eye could capture.

This remarkable little book, first published in 1954, long ago became a collector's item. Today its republication is a tribute to both Philippe Halsman, a great photographer, and to a showman named Salvador Dali, who, fortunately for us all, "also painted."

A. Reynolds Morse
President
The Salvador Dali Foundation
St. Petersburg, Florida

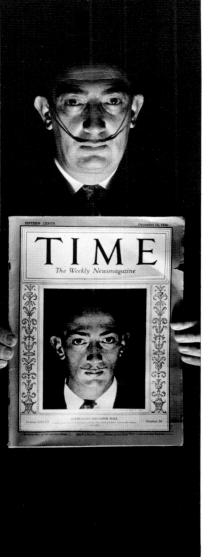

PREFACE
by Salvador Dali

WHEN I WAS three, I wanted to be a cook. When I was six, I wanted to be Napoleon. Since then my ambition has done nothing but grow.

At the age of 29, I undertook my first American Campaign. On the day I disembarked in New York, my photograph appeared on the cover of *Time* magazine. It showed me wearing the smallest mustache in the world. Since then the world has shrunk considerably while my mustache, like the power of my imagination, continued to grow.

Since I don't smoke, I decided to grow a mustache—it is better for the health. However, I always carried a jewel-studded cigarette case in which, instead of tobacco, were carefully placed several mustaches, Adolphe Menjou style. I offered them politely to my friends:

"Mustache? Mustache? Mustache?"

Nobody dared to touch them. This was my test regarding the sacred aspect of mustaches.

In the Bible great significance is attributed to the growth of human hair. Delila believed in the power of hair; Dali does too. In the 17th Century, Laporte, the inventor of "Natural Magic," considered mustaches and eyebrows as antennae

susceptible of capturing creative inspirations, as do antennae of insects whose instinctive life is more refined. The legendary eyebrows of Plato and, even more, those of Leonardo da Vinci, almost covering his vision, are the most renowned testimony to the glory of facial hair.

But it was the 20th Century, in which the most sensational hairy phenomenon was to occur: that of Salvador Dali's mustache.

Many marvelous and inspirational uses of this mustache are shown in this book. But every day I find new ones. This very morning, and just at the moment of not shaving myself, I discovered that my mustache can serve as an ultra-personal brush. With the points of its hair, I can paint a fly with all the details of his hair.

And while I am painting my fly, I think philosophically of my mustache, to which all the flies and all the curiosities of my era came to be monotonously and irresistibly stuck. Some day perhaps one will discover a truth almost as strange as this mustache — namely, that Salvador Dali was possibly also a painter.

MAY I ASK YOU A FEW QUESTIONS?

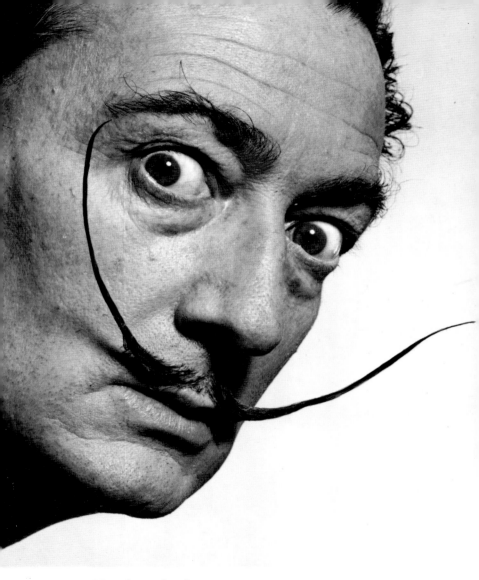

Yes, but don't try to uncover my secret.

WHY DO YOU WEAR A MUSTACHE?

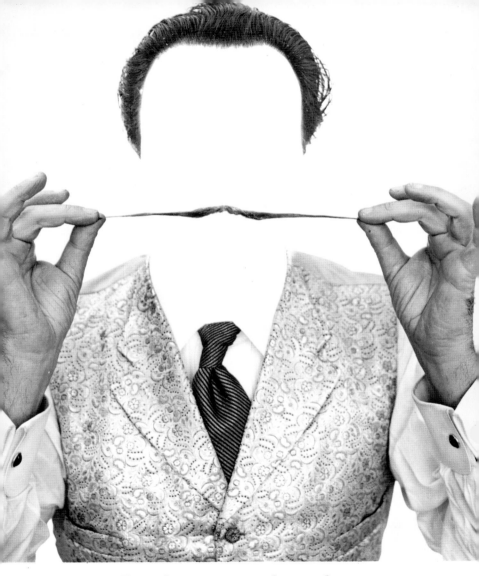

In order to pass unobserved.

AS USUAL, I DON'T FOLLOW YOU.
WHAT DO YOU MEAN?

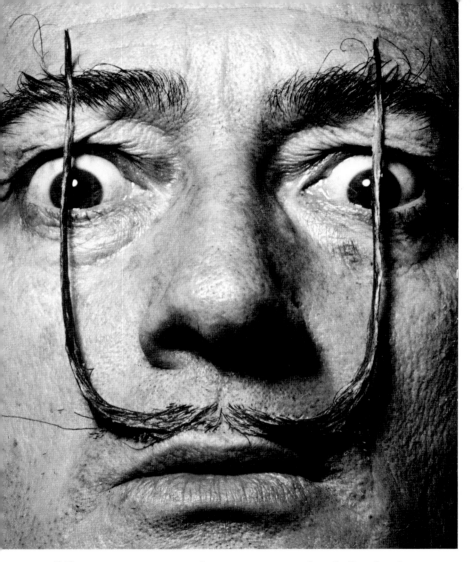

Like two erect sentries, my mustache defends the entrance to my real self.

ARE TWO SENTRIES ENOUGH?

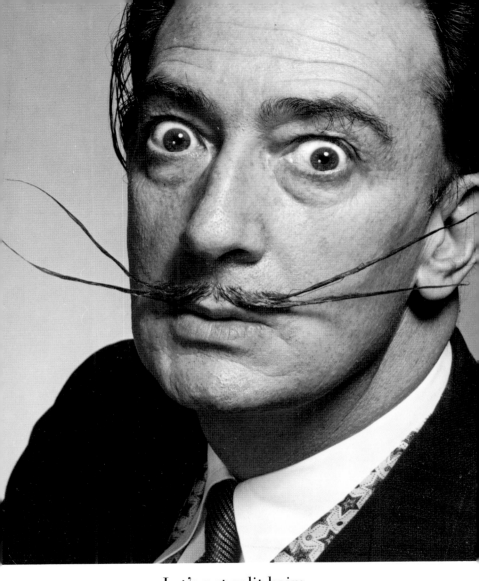

Let's not split hairs.

BUT MUST IT ALWAYS BE ON THE
DEFENSIVE?

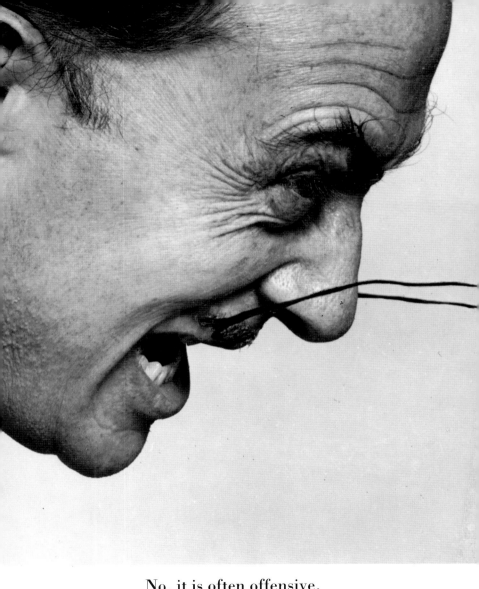

No, it is often offensive.

ISN'T YOUR MUSTACHE IMPRACTICAL—ESPECIALLY WHEN YOU TRAVEL?

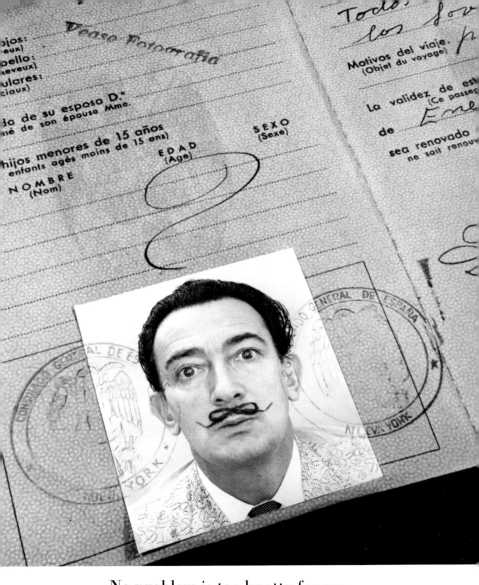

No problem is too knotty for me.

WHY HAVE YOU NEVER BEEN PSYCHOANALYZED?

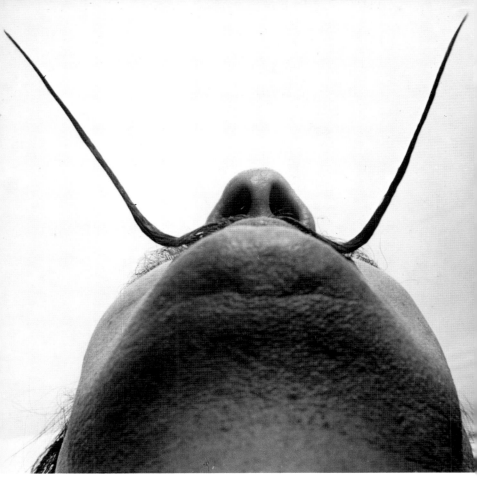

No analyst could ever take me lying down.

HOW MANY TIMES HAVE YOU TRIED?

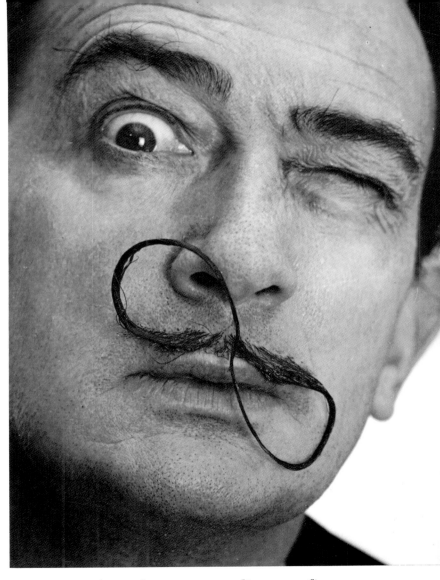

A gentleman never discusses figures.

WHY DO YOU PAINT?

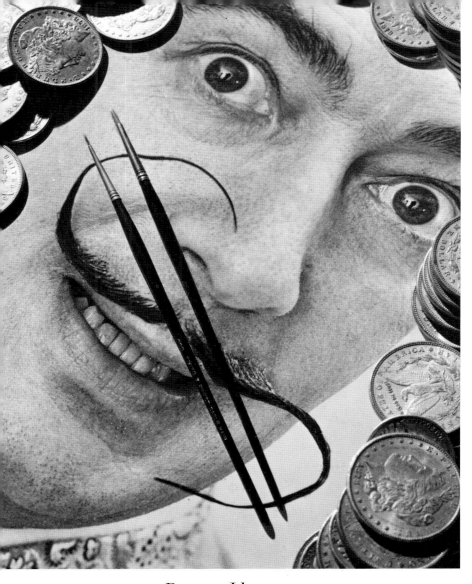

Because I love art.

AND HOW'S BUSINESS?

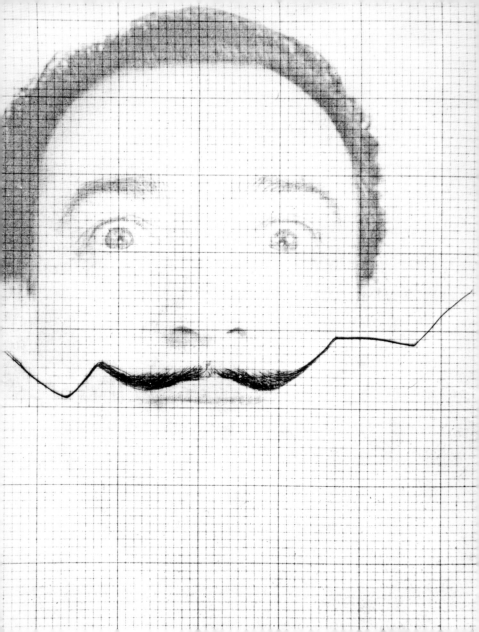

HOW DO YOU GET SUCH SUPERB DETAIL IN YOUR PAINTING?

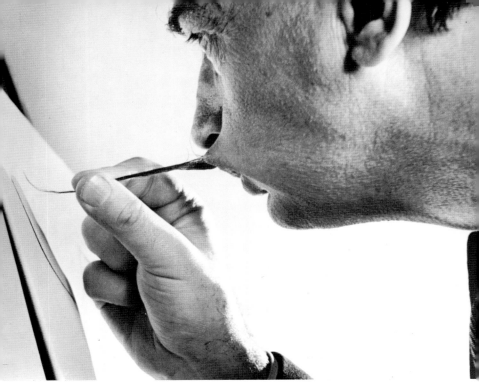

Nature gave me my best tools.

HAVE YOU EVOLVED A DEFINITE STYLE?

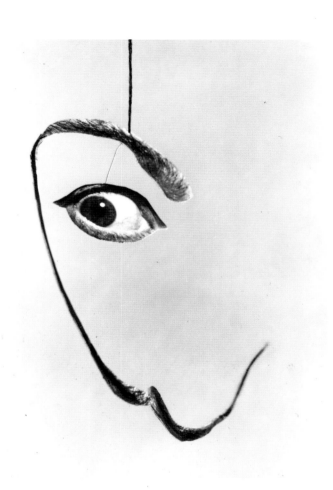

No, I am completely mobile.

WHAT IS UGLINESS?

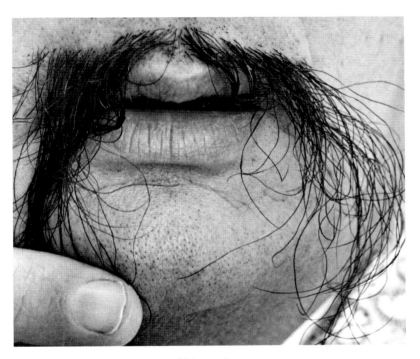

Disorder.

WHAT IS BEAUTY?

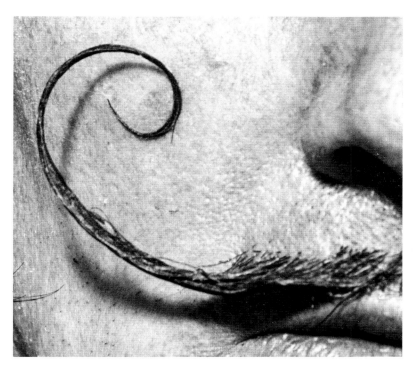

Harmony.

WHAT IS SURREALISM?

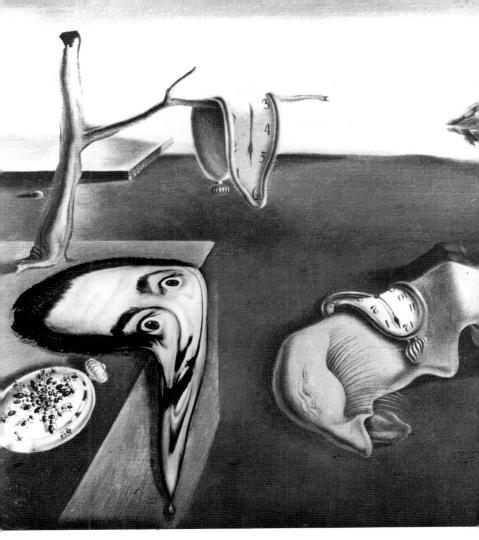

Surrealism is myself.

ARE YOU ALWAYS SO SURE OF
YOURSELF?

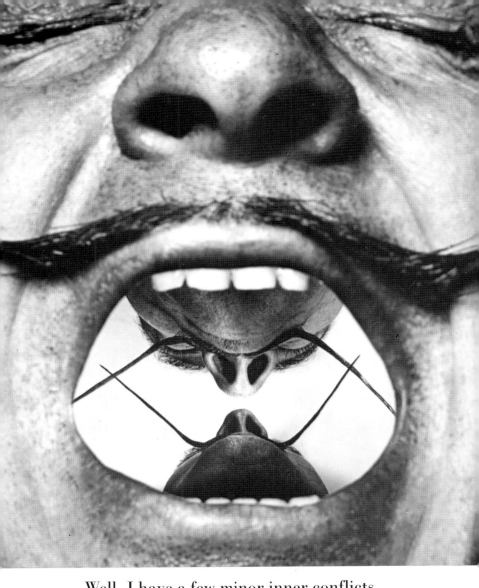

Well, I have a few minor inner conflicts.

CONFIDENTIALLY, AREN'T YOU AN EXTROVERTED EXHIBITIONIST?

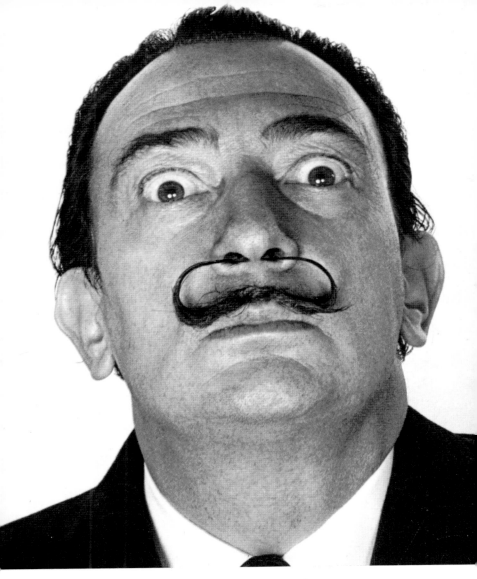

Nonsense, I am an ingrown introvert.

DALI, WHAT IS YOUR SECRET OF SUCCESS?

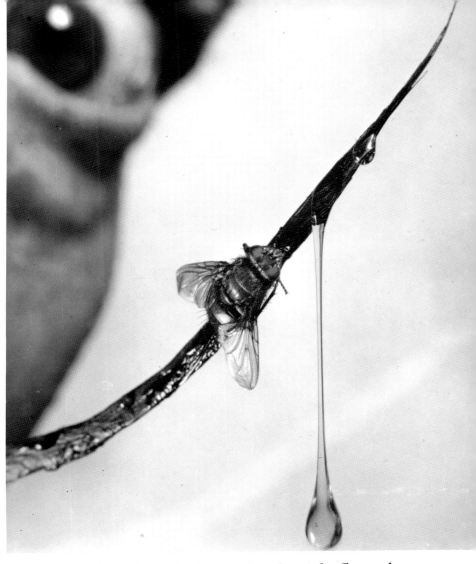

Providing the right honey for the right fly at the right time and place.

DOES A SUCCESSFUL ARTIST LIKE YOU CARE MUCH FOR PRAISE?

HOW DO YOU OBSERVE MOTHER'S DAY?

I am always fishing
for compliments.

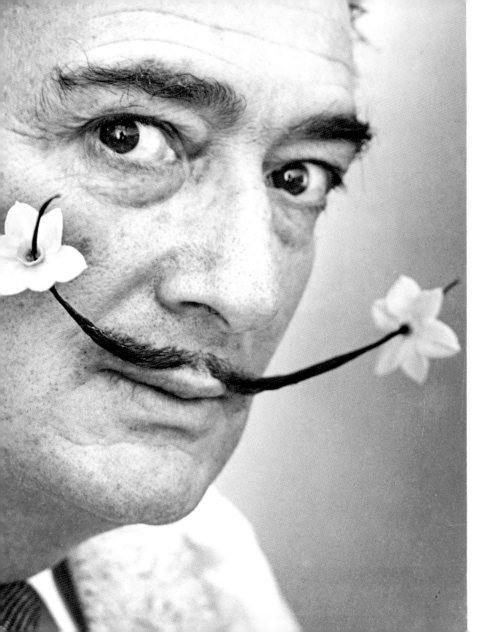

DALI, I KNOW THERE IS A RAGING BULL HIDDEN IN YOU, AS THERE IS IN EVERY SPANIARD. IS THERE ANYTHING THAT WOULD BRING IT OUT?

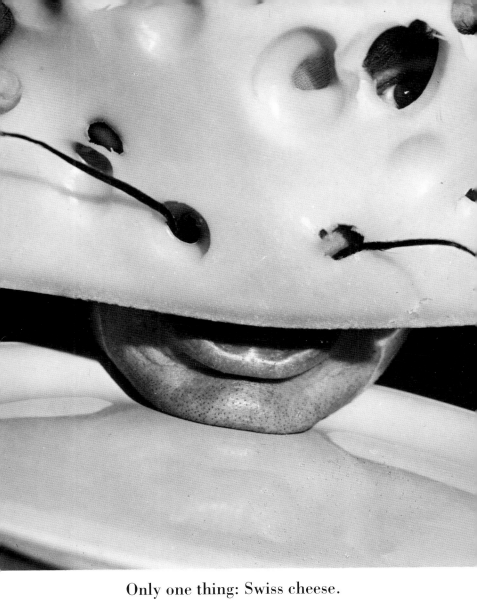

Only one thing: Swiss cheese.

WHAT IS YOUR FAVORITE PERFUME?

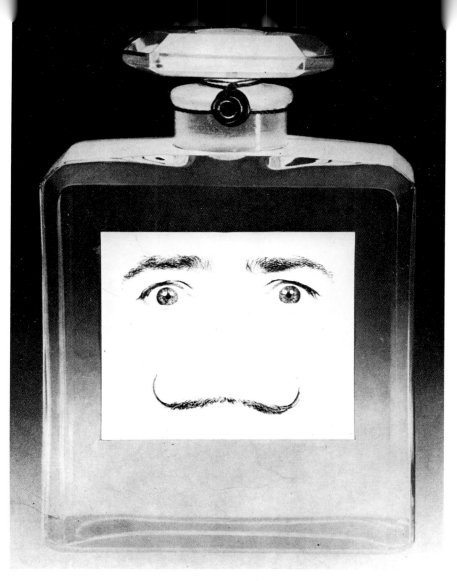

The essence of Dali.

WHAT DO YOU THINK OF COMMUNIST GROWTH DURING THE LAST HUNDRED YEARS?

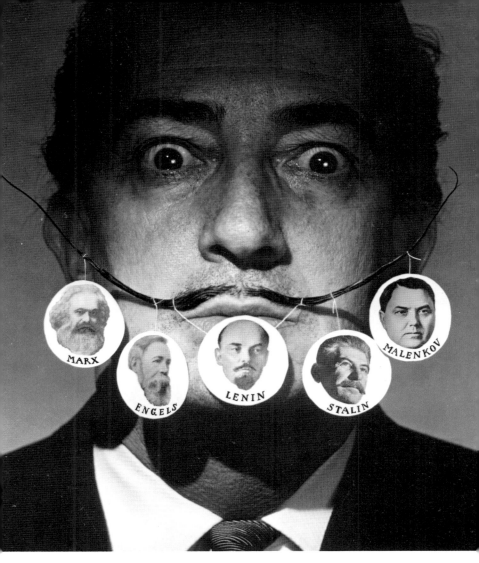

From the point of view of hair on the face, there
has been a steady decline.

YOUR MUSTACHE LOOKS SO RIGID—HOW DOES IT REACT TO THE WINDS OF PUBLIC OPINION?

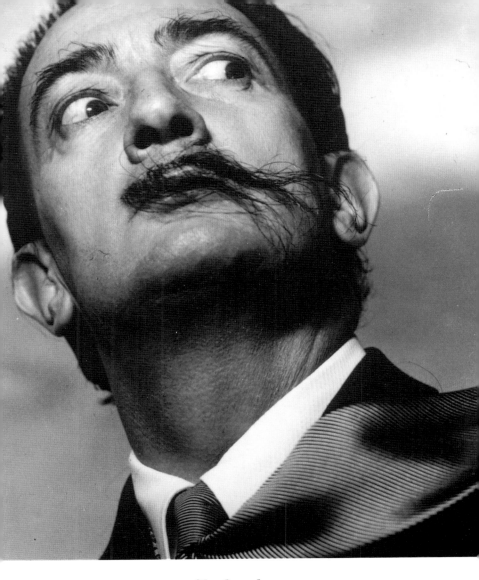

She bends.

DALI, WHAT MAKES YOU TICK?

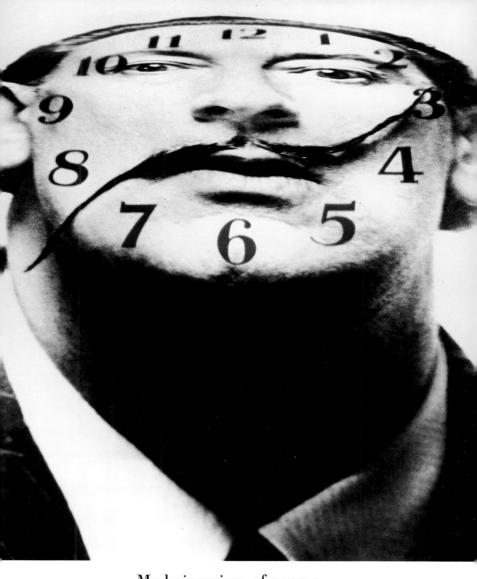

My hairspring, of course.

DALI, WHAT DO YOU SEE WHEN YOU
LOOK AT MONA LISA?

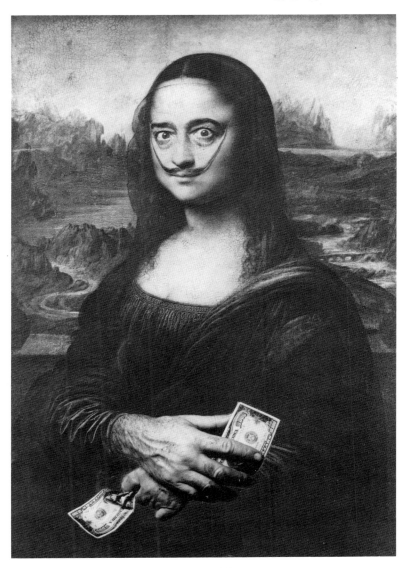

A paragon of beauty.

DO YOU THINK THAT A PAINTER OF
YOUR STYLE BELONGS IN OUR
ATOMIC ERA?

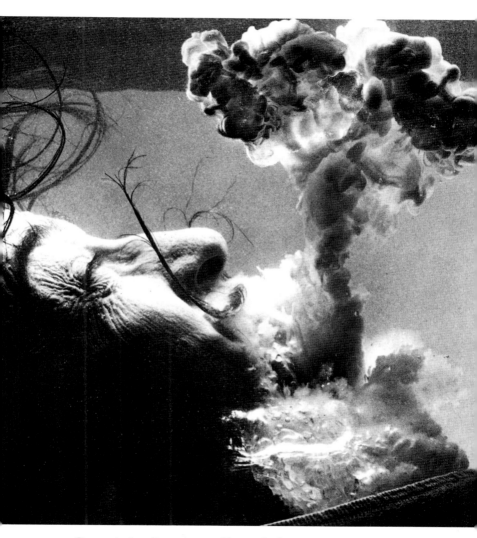

Certainly. I personally indulge in atomic explosions.

I HAVE A HUNCH I HAVE DISCOVERED
YOUR SECRET, SALVADOR. ARE YOU·
CRAZY?

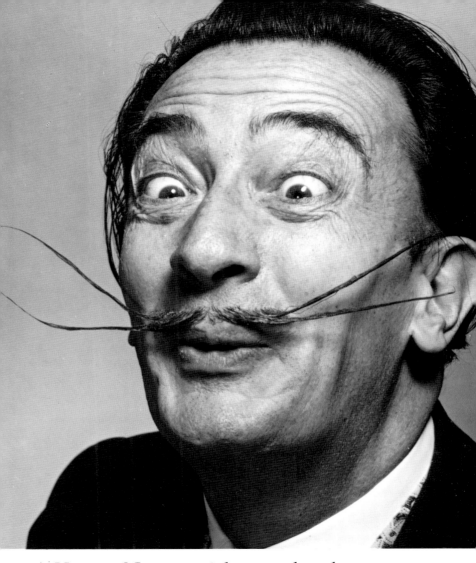

Me crazy? I am certainly saner than the person who bought this book.

POSTFACE
by Philippe Halsman

How it started.

THERE WERE TIMES when deeds were less important than whiskers. Remember Barbarossa? Everybody knows about his beard, but only historians know about his achievement. With the death of Kaiser Wilhelm, Hitler and Stalin, with Chaplin's withdrawal from the screen, the era of great mustaches seemed to have come to an end. A desolate, whiskerless vacuum followed.

But when, last November, I saw that Dali's mustache had suddenly reached his eyebrows, I realized that Dali had stepped into this vacuum. This great painter had become the great mustache of our times.

As a photographer I saw my duty. I switched on my lights and for three hours I photographed the play and interplay of his mustache. Like two worms, its two branches could twist and turn in any direction. So could the conversation of its owner:

"Many American tourists visited me this summer in Spain. Did they want to see my paintings? Not at all! They were only interested in my mustache. The public does not need great painting. What it needs is a better mustache."

A few days later I went to see my publisher, Dick Simon, about a recently published fairy tale of mine. Noticing a large envelope under my arm, he inquired about its content.

"I have an appointment with a *Life* editor," I said, "I promised to show him a few hair-raising photographs."

Dick looked at my pictures, laughed, lingered over the words "Dali's Mustache" scribbled on the envelope and remarked:

"Why don't you make it into a book?"

The idea struck me as preposterous. But after all I had had the identical reaction when Dick first suggested making a book of my pictures of Fernandel. Subsequently, the book, *The Frenchman*, fathered scores of imitations and . . . I am still driving a convertible which, in fond financial memory, I call Fernandel.

And here at last was the opportunity to realize one of my ambitious

120

dreams—to create a work of major preposterousness. I said: "I will try this idea on Dali."

I approached the great surrealist cautiously:

"Books have been written about you and other painters. But there is no book about a part of their personality, as, for instance, Raphael's nose or Picasso's foot. What a tribute to your talent, Dali! A book to appear—dedicated not to the whole but only to a small part of you!"

The immensity of the tribute visibly touched Dali. I thought it only fair to warn him: "It is a purely idealistic venture. I can hardly imagine anybody buying such a book."

"Nobody realizes the commercial possibilities of my mustache," said Dali. "Only yesterday a TV network offered me $500 for the right to televise it for 10 minutes."

How we did it.

WE HAD TO create new pictures, and months of experiments and hard work followed. It was a true collaboration. Some of the picture ideas were Dali's; for instance, the mobile, the Mother's Day, the graph. Some of them originated with me, like, for example, the inner conflicts, the ugliness, the Swiss cheese. But the majority were born of the intercourse of our minds. The captions were fathered similarly.

Dali gave evidence of an admirable cynicism and an amazing objectivity. I asked him: "How will you answer the question 'Why do you paint?'"

Dali said: "I will answer: 'Because I love art,' but my mustache will make a dollar sign."

Later he scrutinized the finished picture and remarked with glowing contentment. "I have the expression of a little rat. It is perfect."

Dali also showed surprising patience and a capacity for suffering. The photograph of Dali through Swiss cheese presented unexpected difficulties. The cheese affected Dali's waxed mustache in a mysterious way. The mustache lost its spring and drooped. Two assistants had to pull it through the cheese holes and hold it up, while Dali tried vainly to peer with his eye through a third hole. It took over an hour to get the picture. Dali's face was covered with a mixture of sweat and Swiss cheese. Half of his eyelashes and a third of his mustache were lost, imbedded in the cheese. But he did not complain.

Another difficult picture was the one with the fly. It was difficult because it was winter when Dali expressed a desire to be photographed with flies

clinging to his mustache. There seemed to be no flies left in New York. Finally I found half a dozen dead ones sticking to dusty cobwebs in the stables at the end of our street. I glued them on Dali's mustache and took several photographs. But Dali is an ambitious man. He did not want small ordinary flies on his mustache, but a big fat manure fly. My entire family was alerted and put on the lookout.

Spring advanced, the sun's rays grew warmer and one day my loyal wife, Yvonne, noticed some big flies sitting on vegetables displayed in front of a vegetable market. She went inside, bought some carrots, made friends with the owner and asked him for permission to catch a few flies.

"Go ahead, lady!" said the owner generously.

"Do you have a fly swatter?" asked Yvonne.

Since he had none, she ran to the nearest Five-and-Ten to buy one. In the meantime the store owner went to lunch and was replaced by his partner. When the partner looked through the store window he saw a strange woman with a brand new fly swatter, socking flies on his vegetable stand. Trembling with rage, he ran out, grabbed my wife by the shoulders and shouted:

"What do you think you're doing here?"

Yvonne stammering, started to explain that she needed the flies to paste to the mustache of a very famous painter, but the vegetable man interrupted her with shouts that she belonged in some asylum. A crowd gathered. Yvonne had some difficulty escaping.

She was still weeping when I found her at home. I tried to calm her but she sobbed:

"They were the most beautiful flies I have ever seen."

It took us two weeks before we found another manure fly.

The photograph which required the most effort was inspired by the most famous of Dali's paintings, his picture of the limp watches. The problem was to substitute Dali's face in place of a watch. I photographed Dali with his mouth open, made a glass diapositive, melted its emulsion, distorted, rephotographed, melted again, distorted again, till I finally had Dali's face melting in the most atrocious way. Together with unsuccessful experimenting it took over a hundred working hours. Only my stubborn ambition to prove that any distortion—so easy in painting and in politics—was also achievable by purely photographic means, kept me from giving up. Now Dali's limp face appears so much an integral part of the painting that when I submitted this picture to a photographic annual, its editor rejected it for not being a photograph.

One day, Dali confided that he always wanted to look like Mona Lisa.
I smiled, because I never felt a remotely similar desire. Dali insisted, and
I was moved by the deep emotion in his voice.

"All right," I said, "I will put your mustache on Mona Lisa's face."

"That is the trouble," exclaimed Dali. "Marcel Duchamp has already
created a scandal by drawing a mustache on Mona Lisa. It would be
plagiarism."

"But I will also give her your piercing eyes and your big hands. She
will be counting money."

Dali's face lit up. One of his dreams was coming true.

Our obsession continued. Ideas swamped us. We had the feeling that
we could fill tomes with mustaches. I found myself refusing assignments
to have more time for my work on Dali's mustache. The mustachomania
spread to my children.

"Daddy," asked my youngest daughter, "Couldn't you photograph Dali
eating his mustache, as if it were noodles?"

Our publisher put a stop to all this. We had passed our deadline by
three weeks.

Is it only a joke?

A YOUNG AND—in spite of her normal IQ—very bright looking actress
told me, after glancing through the pictures of this book:

"Some of them give me an icky feeling. I cannot look at them without
wincing."

Then she added: "Why do you seem so happy about it?"

"Because it proves that they have some of the quality a surrealist's
work should have."

"I don't understand," she said timidly.

"Most people don't understand surrealism. They confuse it with sym-
bolism or they think it is an art style, like, for instance, impressionism.
But surrealism is not a style, it is a method of creating. There cannot be
such a thing as an impressionistic bathtub. But Dali's famous fur-lined
bathtub in Bonwit Teller's window was a surrealistic object par excellence.

When a surrealist creates, he is not controlled by his intellect or any
moral standards; he creates with his subconscious mind. A Raphael
sought harmony; a surrealist tries to disturb. His work is not directed at
our reason; it aims straight at our subconscious. If you wince, it is proof
positive that he has scored a direct hit on your libido."

I looked with curiosity at the picture which had so deeply disturbed

123

the young actress. She blushed and closed the book. Then she said:

"I'll ask you a question you probably have heard many times. Is Dali crazy?"

"Dali is a surrealist," I answered. "The most surrealistic of all his creations, however, is himself. I don't know which made him more famous: his paintings or the legend he helped to create."

"Exactly what I thought—crazy like a fox!"

"A very unhappy simile! As if being a fox were a protection against being crazy. No, Dali is as sincere as a child who will sometimes hurt himself to make his make-believe more real. Take, for instance, this book. In the eyes of the so-called serious people, it might hurt Dali's prestige as one of the world's foremost painters."

"But is he aware of it?"

"Of course!" I said. "But what could he do? He owed the book to his mustache. You know, the two are deeply attached to each other."

The young actress sighed, for reasons known only to herself, and asked:

"But you, Philippe—what do you think about Dali's mustache?"

I thought of the many, many hours spent in the darkroom, at work on this mustache, and sighed too.

"For me," I said, "Dali's mustache has become a symbol. André Gide ended his *Nourritures terrestres* with the words:

" '. . . et crée de toi, impatiemment ou patiemment, ah! le plus irrem-plaçable des êtres.' "*

The great lesson of Dali's mustache is that we all must patiently or impatiently grow within us something that makes us different, unique and irreplaceable."

"Oh no!" exclaimed the actress. "A mustache with a message! How much more preposterous can one get?"

"You really mean it?" I asked happily, "Or are you just trying to flatter us?"

*'. . . and create out of yourself, impatiently or patiently, ah! the most irreplaceable of beings.'

PUBLISHER'S NOTES

ON HOW SOME OF THE PHOTOGRAPHS WERE MADE

(OF INTEREST CHIEFLY TO PHOTOGRAPHERS)

Cover Picture—This photograph was made some years before the rest of the pictures in the book—as is quite evident from the Kaiseresque aspects of Dali's mustache at the time. Halsman had made a three-quarter view of Dali's face, as can be readily discovered by covering the left half of the photograph. In the printing, Halsman reversed the negative for one-half the exposure. Don't ask us how he covered up the other half. Dali fell so much in love with this picture that when the mayor of Málaga, Spain, asked him for permission to build a statue of him, Dali gave this picture as the model to be used. A three-dimensional effigy was built, 30 feet high, showing his face on both sides. It was erected in the public square, and then burned on March 10th, 1954, in honor of St. Macarius.

PAGE 15—(**"In order to pass unobserved"**) This was made as a regular portrait. Before printing the negative, Halsman painted out the face with New Coccine, a red chemical which, in printing, can be made to obliterate all detail on the negative.

PAGE 19—(**"Like two erect sentries my mustache defends the entrance to my real self"**) This is a blow-up of a relatively small portion of the negative. This might be the best place to note that for most of the pictures in the book, Dali made up his mustache with Hungarian Mustache Wax. Halsman adds that it is obtainable in the United States at two stores, whose names and addresses we do not know.

PAGE 31—(**"No problem is too knotty for me"**) Halsman insists that Dali himself tied the bow. Again a tribute to the versatility of Dali and the Hungarian Mustache Wax. The finished print was pasted on Dali's personal passport. Both Dali and Halsman disclaim having anything to do with the question mark over the subject's head, which was evidently filled in by a passport clerk who became confused in the presence of a great artist.

PAGE 35—(**"No analyst could ever take me lying down"**) Since Halsman has no analyst's couch in his studio, poor Dali had to lie on the floor. Halsman lowered his Rolleiflex, focused on Dali's nostrils, and set off the Strobe lights.

PAGE 39—("**A gentlemen never discusses figures**") A photograph showing the superb cooperation between Hungarian Mustache Wax, a wink, a well-coordinated series of Strobe lights and a dash of Surrealism.

PAGE 43—("**Because I love art**") On the finished print, Halsman laid two spotting brushes over Dali's mustache, and surrounded the picture with silver coins. Then he re-photographed the print.

PAGE 47—(**No caption**) This is double printing. First, Halsman made a negative of some graph paper, which he printed in his enlarger. Then, on the same piece of paper, he made a very weak exposure of Dali's face, giving some extra exposure time to the mustache alone. In case this puzzles you, consult one of your amateur photographer friends.

PAGE 55—("**No, I am completely mobile**") Watch this closely. Since Dali's mustache is touching his right eyebrow, Halsman cut the mustache and eyebrow out of the print. Then he cut out the eye, attaching it with thin wire to the eyebrow. Then he hung this mobile from another wire in his study. (There must be some easier way of making a living.)

PAGE 59—("**Disorder**") A closeup of Dali's mustache, uncombed and minus the Hunagarian Mustache Wax.

PAGE 63—("**Harmony**") Showing what happened when the Hungarian Mustache Wax was re-applied. (Special research note: The ancient Greeks considered the logarithmic spiral as a symbol of perfect harmony.)

PAGE 71—("**Well, I have a few minor inner conflicts**") Again, your attention please:
When Halsman took Picture No. 7, he made a number of exposures. He double-printed two, in order to show one Dali mustache fencing with another Dali mustache. (Are you still with us?) Then he cut out the mouth of another photograph of Dali, being careful to leave a few teeth on both the upper and lower jaws. In order to give depth, the fencing-mustache print was placed about a foot behind the photograph of the now mouthless Dali print, with the camera focused on the fencing mustaches. (It's things like these which have delayed publication of this book for months.)

PAGE 79—("**Providing the right honey for the right fly at the right time and place**") This is the only photograph in which Dali's mustache is not 100% genuine. By the time the weather grew warm enough for Mrs. Halsman to capture and bring home the large manure fly, Dali

had left for Europe. Dali, however, had been forehanded enough to construct a hair replica of his mustache, and applied his beloved Hungarian Mustache Wax to it. Halsman glued the fly to the *Ersatz* mustache, and placed it in front of part of the first portrait in this book. Then he and Mrs. Halsman spent hours pouring the right amount of honey at the right time on the right part of the mustache and shooting the picture when the drop of honey formed at the right place.

PAGE 83—(**"I'm always fishing for compliments"**) We wondered about this one too. It was readily explained by the photographer: There was no weight attached to the end of the string.

PAGE 91—(**"Only one thing: Swiss cheese"**) Note to non-cheese eaters: If you try this, use imported Swiss cheese. The holes in the domestic variety are too small.

PAGE 99—(**"From the point of view of hair on the face, there has been a steady decline"**) Marx, Engels, and Lenin were photographed out of an old French encyclopedia. The head of Stalin comes from Margaret Bourke-White's book, *Shooting the Russian War*, and is reproduced with her permission. Malenkov was more expensive. His photograph was purchased from a photographic agency. Each of the pictures were printed approximately the same size, pasted on white circular cardboard, and hung from Dali's mustache. A spotlight was focused on the Communist leaders, leaving Dali's chin and forehead in comparative gloom.

PAGE 103—(**"She bends"**) Made by de-waxing, a few brush strokes, and a General Electric fan.

PAGE 107—(**"My hairspring, of course"**) After having photographed tens of thousands of faces, Halsman became convinced that the textbooks are right: each face is subdivided into three parts—forehead, nose and chin. Problem? How to place the axis of the mustache smack in the middle. This was solved by an exercise in progressive photographic distortions. First Halsman enlarged a photograph of Dali's face by distorting the image in the enlarger. This did not produce enough distortion, and he next photographed this enlargement at a distorted angle. This second negative was then further distorted in the enlarger. This whole process was repeated once more—with the resultant appearance of Dali's circular face that we see looking down from above. The watch numerals were photographed from an old watch dial, which again had to be distorted to fit Dali's distorted face. Question: Is it 22½ minutes to three or quarter past seven?

PAGE 111—("**A paragon of beauty**") And here is an exercise in semi-vandalism. It's Mona Lisa all right, but how did those eyes, that mustache, those strange hands, and those coins creep in? Answer: First, Halsman asked Dali to pose, looking like Mona Lisa. From the finished enlargement, he cut out the eyes and mustache, and pasted them on a reproduction of Leonardo's immortal masterpiece. Problem: The Mona Lisa painting had some perpendicular cracks. With a fine pen, Halsman drew in cracks to correspond. (What do we mean—*semi*-vandalism?) Then about those hairy hands—and here we go into a real by-path. One of the photographs that we unfortunately were unable to include in this book, was a portrait of the Spanish maestro with a $10,000 bill hung on each side of his mustache. Two $10,000 bills were borrowed from the Bankers Trust Company and sent to Halsman with an armed guard who had his revolver exposed in a holster. He scared the Halsman household half to death. The two $10,000 bills were photographed in Dali's hands for the Mona Lisa picture. When the proofs were ready, they were sent for O.K. to the Secret Service Branch of the Treasury Department. No soap, they said—their point being that even though the large bills were discreetly folded to prevent photographic forgery, nevertheless the Federal law was discouragingly explicit. Too bad, for we rather liked the caption for the $10,000 bills draped on Dali's mustache. It was to have been: "Is your mustache insured?" By the time refusal came from the Treasury Department, Dali had gone abroad. In the final photograph, substitution was made of silver coins, and of Halsman's instead of Dali's hands [Publisher's note: The law has been changed and the present edition includes the original photograph].

PAGE 115—("**Certainly. I personally indulge in atomic explosions**") In order to take this picture of Dali under water, Halsman ordered a special aquarium, 1 foot deep and $1\frac{1}{2}$ feet long, with a transparent bottom. Dali took off his tie, and looked at the water-filled aquarium, with the expression of a man being led to execution. Halsman wondered whether Dali would be able to open his eyes under water. He asked Dali: "Do you swim?" "Why," answered Dali—his voice breaking—"Is there any danger?" Now what about that atomic-looking explosion? This was made with milk which Dali had thoughtfully concealed in his mouth and squirted out when the Strobe lights went off.

PAGE 119—Halsman and Dali were discussing McCarthyism when the Strobe light accidentally went off.